MAY 2018

Humanity

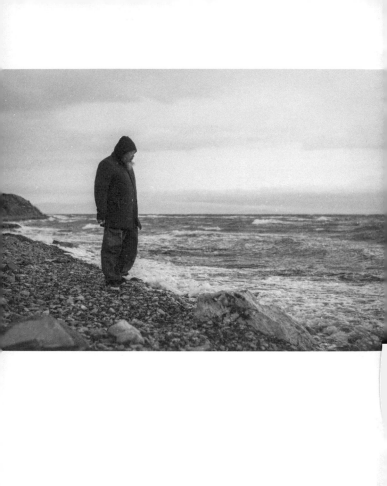

Humanity

Ai Weiwei

Edited and with an introduction
by Larry Warsh

PRINCETON UNIVERSITY PRESS
Princeton & Oxford

Requests for permission to reproduce material from this work
should be sent to Permissions, Princeton University Press
Published by Princeton University Press, 41 William Street,
Princeton, New Jersey 08540
In the United Kingdom: Princeton University Press, 6 Oxford
Street, Woodstock, Oxfordshire OX20 1TR
press.princeton.edu
ISBN 978-0-691-18152-3
Library of Congress Control Number: 2017964480

British Library Cataloging-in-Publication Data is available

Cover design by Pamela Lewis Schnitter

Typeset by Jeff Wincapaw

This book has been composed in Joanna MT

Printed on acid-free paper. ∞

Printed in the United States of America

1 3 5 7 9 10 8 6 4 2

CONTENTS

INTRODUCTION

What is our human obligation? This is a pressing question, now more than ever. Thousands of people are displaced every day, and too few people are turning their attention to this crisis. As a child of refugees, I easily see that history is repeating itself. In the current refugee crisis the same stories my parents told of their property being seized, their possessions stolen and destroyed, and their loved ones forcibly uprooted are reemerging. The tragedies they endured are faced by millions of people around the globe at this very moment.

Ai Weiwei, a former refugee himself, shares this sentiment and is helping to keep the collective voice of the refugees at the forefront of art and politics. *Humanity* illustrates Ai Weiwei's thinking on a journey through twenty-three

countries confronting and documenting the realities of the current global refugee crisis. Selected from a variety of sources, including interviews, magazine features, and podcasts from numerous countries, these quotations reflect the diversity within Ai Weiwei's voice. As he speaks to a range of audiences, his words are expressed through many tones to illustrate the complexity of the crisis. Above all, he brings awareness to these human rights issues in light of an atmosphere of indifference in which those with the power to act have failed to do so. He calls not only on governments and authorities, but on individuals. No action is too small and no action is too late.

This appeal comes at an urgent moment. As 2018 begins, over sixty-five million people have been displaced worldwide, with many countries adopting truly disheartening exclusionary policies in response. Ai Weiwei's unwavering focus

on this humanitarian crisis reflects the hope that art joined with political dialogue can lead to greater consciousness, support, and healing among human beings.

I stand with Ai Weiwei and his belief that every human being deserves the same aspirations: to make the most of the lives we are given, to infuse our world with meaning and sensitivity, and to confront the obstacles facing us. To fulfill these aspirations, we are called upon to use our own individual power to aid those whose power has been stripped from them. We must resist complacency and indifference, and strive to bring immediate and sustained attention to this crisis on a global scale. It is our collective responsibility to inspire the world with freedom, empowerment, creative expression, and determination. This is our obligation.

LARRY WARSH

Humanity

My conclusion is we are one humanity.
If anyone is being hurt, we are all being hurt.
If anyone has joy, that's our joy. (1)

———

A refugee could be anybody. It could be you
or me. The so-called refugee crisis is a human
crisis. (2)

———

Being part of humanity is hard for us to
understand. If you are a tree, it's hard to
understand the forest. (3)

———

How we look at other people very often tells
us about ourselves. I think that's an honest
reflection of the nature of human beings. (4)

———

If you help one person, you help humanity. (5)

———

I want to show the refugees' beauty. I want to show that even under the most difficult circumstances, the beauty is still there. The beautiful and the dark exist in the same picture. (6)

———

I have great sympathy for people who fear migrants, for their lack of knowledge, and as a result, their lack of understanding of humanity. (7)

———

As human beings, we are lucky enough to have imagination. Our hearts can be so big, we can imagine beyond the physical boundary. Humans are so beautiful in that way. That's why we have poetry, we have music, we have art. (8)

———

Humans do not rule the universe. We are temporary passengers. (9)

———

We have a saying in China: water, if it drips long enough, can penetrate a stone. We must look at things with this perspective. It always comes down to some kind of struggle. It can take ages, but the human spirit—our will to be free, to have a chance, to communicate face to face, to shake hands and to share space—is much stronger than anything. (10)

—————

I cannot give all the refugees food, tea, or money, but I can let their voices be heard and recognized. I can give them a platform to be acknowledged, to testify that they are human beings. (11)

—————

I was born when my father was a refugee.
I understood how low humanity can go. (12)

As an artist, I have to relate to humanity's
struggles. I never separate that from my art.
(13)

Humanity is losing its vision and courage. (14)

I think the refugee crisis is a global crisis, it's a
human crisis. We cannot just say it's a refugee
crisis. It's not regional, it's not just happening
in the Middle East. It also happens in Africa, in
Bangladesh, in many, many other locations.
(15)

In any kind of religion, to save one life or to help one life is the highest ritual. Nothing can be higher than that. (8)

———

You begin to understand that we all have the same basic needs, that our sense of humanity and integrity, our desire for warmth and safety, to be well-treated and respected, are the same. (16)

———

I was not born an artist, I was born a human. I care about human conditions, rather than the opinions of others. I don't have a choice. (17)

———

We always have to share compassion with other people—otherwise, how can we call ourselves human beings? (8)

———

Drones are fascinating—they offer a point of view which is not the human point of view. It's from either a bird, or from God. Looking at a human this way can be so indifferent. And it shows the flow of refugees as some part of the nature—it's like water flowing, or ice melting. I like that kind of metaphor, because we very often talk about how different and how foreign those people are. (18)

———

In this society, we talk about individuality—is that really there without essential rights? (19)

———

Human rights always need to be defended everywhere, and by doing that, we benefit everybody. (20)

———

Art is about aesthetics, about morals, about our belief in humanity. Without that there is simply no art. (21)

———

If we feel that one human being is connected to another, then we have the solution. If we talk about geo-politics, legislation, and technical problems, then we miss the point.

(22)

———

It is human nature to believe that we are so smart, that we control the universe. But, at the same time, human nature is suicidal, because we never fully appreciate how temporary and ephemeral our fate really is. (3)

———

There is the religious argument that human beings, from a certain height, are all the same. (9)

———

This refugee crisis is testing and challenging our humanity, within everybody. We have to understand we're all part of it. (23)

———

We're all human beings. We have to find a way to benefit each other, to help each other, rather than to have hatred toward each other. (24)

———

People are saying, "We are better than them. They are the danger. They are the problem." It's not recognizing humanity as one. It's against the ideology that we're all created equal, and it's a violation of our understanding of human rights and human dignity. (25)

———

I really question our ability to imagine ourselves in other people's conditions, and if we don't start doing that, I don't think humanity has any hope. (4)

———

You see humanity struggling with the worst conditions and the worst situations, but you also see the people who have lost everything or who gave up everything for their children or their family—you see the very brave side of humanity. (26)

———

I feel people and I feel their pain. I have strong feelings when people are treated differently, when humanity is not as one, not connected.

(27)

———

Artists don't have to become more political, artists have to become more human. (17)

———

I always see humanity as one. If someone's rights are violated, we are all deeply hurt. (8)

———

In this time of uncertainty, we need more tolerance, compassion, and trust for each other since we all are one. Otherwise, humanity will face an even bigger crisis. (28)

———

Artists must trust that they can relate to essential human needs, like the breathing of air and the thirst for water. Whatever is produced should share those essential elements of life. (29)

———

The most difficult part is that you see that
the refugees desperately need some
understanding. It's not really that they need
money. They need people to look at them
and see them as human beings. (30)

———

During the saddest moments in our history,
mankind has had to prove their worth as
humans to their own kind. (11)

———

To get yourself involved, to make the situation a little bit lighter, to make some jokes, to cut hair or barbecue, it brings a human touch. It's everyday life. It's humanizing them, and humanizing myself. (31)

———

To picture the refugees as dangerous and to relate the name "refugee" to "terrorist" or "a threat to society" is extremely narrow-minded and cold. It will not help our society to become a healthy society. (32)

———

Yes, we have different religions, different backgrounds, different languages, but humanity is one; we're all vulnerable. We all want to have safety and for our children to have possibilities. We need to protect each other. (32)

In today's Europe we see a lot of people trying to push refugees away. Humanity will always win. I don't think this kind of segregation and hatred can win. (33)

Human flow has always happened in human history. In many cases, it's part of our humanity and our civilization. (34)

This is a moment to challenge what kind of humanity we have today, and how we look at the refugees: Are they part of us? Are we willing to recognize we are part of the problem? (18)

———

We have to give every refugee essential protection. The tragedy is not only that people have lost their lives. The tragedy is the people who, in the very rich nations, have lost their humanity. (35)

———

The most profound thing is how we respect humans in this society, how we establish love and protect rights and establish the essential idea that we are all the same. (36)

———

You have to see them as normal human beings just like anybody else, rather than to think you have to give mercy to them. (37)

———

My utopian vision is based on the idea that all men are created equal and that life is precious. (38)

———

I cherish beauty and aesthetics even in the worst conditions. I think that is related to the best part of our humanity—we are dreamers, we have imagination. (39)

Crisis

They leave the war zone, but this is a different war. They leave behind the bombs and explosions, but when they enter Europe, they see how they've been abandoned. (40)

———

On some boats you find children unaccompanied. When you have given your children away, that is when you have given up. (17)

———

This isn't a single person. It's many millions. World-wide more than 60 million people have lost their homes, and more are losing them every day. (41)

———

It surprised me to see so many children not crying. They're just like adults—it's wet, it's cold, it's an unacceptable situation. Their tears must be all used up. (42)

———

History teaches us that at the beginning of the greatest tragedies was ignorance. (43)

———

People are dying. Women and children are bombed by drones, and we pretend we don't know it. (44)

———

When you see so many children out of school—263 million children worldwide—you can easily predict what our future holds. (11)

———

I couldn't believe what I had seen. I felt an inner need to grab that reality, it looked so surreal. The reality of this refugee situation should be shared. (45)

———

I believe we have lost the capacity for compassion. Maybe that has something to do with our information age. We see the refugees' misery on the news daily, so we know what is happening. At the same time, the pictures dull us. We think that the misery is so great that we cannot do anything about it. (43)

———

People drown. Children drown. Nothing can prepare you for seeing all these people in their desperation. (47)

———

When we talk about one person drowning, that's perhaps normal. But when you see over 3,000 people have drowned, then you really have to confront the question: Do we really care? (48)

———

If you offer something to the children, they
often ask their parents, "Should I take it?"
They have dignity. They're not beggars.
They come only because if they didn't,
they would die. (8)

My moments with refugees in the past
months have been intense. I saw thousands
come daily, children, babies, pregnant women,
old ladies, a young boy with one arm.
They come with nothing, barefoot, in
such cold, and they have to walk across
the rocky beach. (50)

I wanted to see the island where the refugees were arriving. I could see in their faces an expression of uncertainty. They were scared and had no idea what they might find in this new land. That, even more, made me want to know more about who these people are, and why they have risked their lives coming to a place they don't understand and where nobody understands them. (51)

————

I know what it's like to be desperate, to lose everything you're familiar with. For these people in Syria to lose everything—their very past and history—it's a human tragedy. (47)

———

Do you know how many refugees have been admitted to the United States since 2013? Only 2500! This is the equivalent of a day of exodus to Greece. The world is not balanced. (52)

———

Once the refugees start to talk they have to stop, because it's hard for them to even repeat. They all have the same stories about human cruelty, violence, abuse and neglect. (8)

———

Women and children are always the first to be victimized and bear the brunt of war, violence and poverty. (47)

———

I think these people feel miserable and their sorrow doesn't just come from war, but from cultural discrimination and isolation by other states. It's impossible to deal or cope with that in a lifetime. Even the following generations might be refugees. (41)

———

The refugee children see how their parents are being badly treated, unfairly treated, the world watching but doing nothing. They see people being killed, homes being burned, the drones blindly dropping bombs. What kind of image would remain in their minds? (53)

The political background behind these conflicts is so complex and difficult to understand. It's a mass murder happening in front of the whole world. We see it and let it happen. We must question our humanity, our democracy and our civilized, powerful society. Do we really want to continue this way or not? We have to face these questions. (54)

Daily we see images of human bodies, a town
or city being destroyed. It doesn't seem real.
It's more exaggerated than a Hollywood
movie. (55)

———

We cannot look at the current situation and
decide it's a regional problem. The crisis is
now becoming increasingly harsh and difficult
to understand, and has the potential to
develop into an even larger problem. (56)

———

What I saw was shocking and unbelievable—a baby being handed out of the dinghy, women climbing out. There was nobody there to receive them. I started to hear their stories. They had to walk 70 hours to reach the point where they can register. They sleep on the road. (57)

———

People are isolated and are being put in a situation to feel powerless. (36)

———

As a human being, I believe any crisis or hardship that happens to another human being should be as if it is happening to us. (58)

———

We see how those men, women and children have lost their life support and safety, and we see people intentionally turning their faces away and coming up with all kinds of reasons to not act. The only conclusion that can be drawn is that there is a lot of inhumanity, cowardice, and selfishness within us. (59)

I think that even in the worst conditions there is still beauty, and that's what I always defend.

(39)

Borders

Nationality and borders are barriers to our intelligence, to our imagination and to all kinds of possibilities. (60)

———

When you shut off the border, you become part of the criminal act. (61)

———

The border you see on the map is not a real border. The real border, the economic border, is never there. It would be a very different map. These borders are only there to stop the most victimized human beings seeking their next meal for their children. (10)

———

Allowing borders to determine your thinking is incompatible with the modern era. (62)

———

The border is not in Lesbos, it is in our minds and in our hearts. (63)

———

Humans create the most ugly fences. (64)

———

Nationality started as something natural, but we should not be restrained by old politics that make up these lines. Nationality should have its own way of evolving. In some places, it will evolve slower and in others, faster. It's like the mountains, the ocean and the rivers. It has its own geological forms. Societies cannot be flat. (60)

———

I hate fences, any kind of fence. It stops people, it separates people, and it makes so many lives so difficult. (65)

———

Borders are there to tear down. As an artist, I constantly come across them: aesthetic, philosophical and social boundaries that limit my work. (66)

———

When I fight for human rights in China, I never think only about human rights in China. I think about human rights everywhere. Human rights is the value which I believe is universal. (67)

———

Today the whole world is still struggling for freedom. In such a situation, only art can reveal the deep inner voice of every individual with no concern for political borders, nationality, race or religion. (68)

———

What's important to remember is that while barriers have been used to divide us, as humans we are all the same. Some are more privileged than others, but with that privilege comes a responsibility to do more. (69)

———

Civilization has evolved toward more acceptance, understanding and tolerance of global thinking. If we accept differences, our creativity booms. (60)

———

Thousands of people are stuck here. You can't believe this is happening in Europe in the 21st century. (70)

———

The fence can be between neighbors to divide, to set up some kind of border. It's about territory, about dividing to push the others away or stop others from crossing. Generally, it reflects a misunderstanding of humanity. (71)

———

Building these walls is a ridiculous act. The emperor of China built the biggest, longest Great Wall. Now people only laugh about it, because it's tourist ruins. It doesn't defend anything, and it's a permanent reminder of the insulting of human dignity. (32)

———

Our biggest danger is that we still see the world as a divided one rather than a total one. In that case, when tragedy happens, you think it's someone else's problem. (72)

———

Fences or territories always relate to our identity, our understanding of ourselves, and our attitudes towards others. (73)

———

When the Berlin Wall fell in 1989, 11 countries around the world were cut off by border fences and walls. By 2016, some 70 countries had built border fences and walls. The U.S. is now trying to build a new wall with Mexico and for me this is unthinkable. This solution has never worked and it testifies to the notion that we have become less courageous. (74)

———

People are not hiding their shameful ideas.
They're even proud to show them. The idea,
"America First," openly boasts of the
superiority of the United States. All of those
ideas are so out of date. It means you
discriminate and dissociate yourself from the
rest of the world. You have the wrong image
and the wrong approach to the human
condition. (75)

———

What shocks me the most are the people who
are so privileged in Europe or elsewhere
who are not taking the refugee
condition seriously. (23)

The physical borders are very different from the political borders, because all those powers are so connected, and you cannot even see whose interest is in what move. (23)

———

I think that human societies are like geographical divisions: mountains, rivers. But in our minds and in our hearts, we don't have to have borders, we only have to recognize humanity as one. (76)

Power

Major nations should bear much more
responsibility for the refugee crisis. (77)

————

I have no illusions about power. Where there
is power there is danger. (78)

————

Inhumanity is rampant in all systems, whether
you grow up in communism, in socialism, in
Buddhism or in Western capitalism. (43)

————

I believe that the people and their government
are not one and the same. (74)

————

Power has to be represented by generosity
and confidence. (79)

Governments do not do enough. They should
feel ashamed. They are going to leave this
world in a chaotic state. (80)

Power is so afraid of art and the poet. Art has
the possibility to defend the very essential
rights. (81)

People also have more power with social media, but we have yet to see them transform it into political power. (14)

———

My message is very clear: as a politician or a political group, you cannot be short-sighted, you cannot sacrifice human dignity and human rights for political gain. (82)

———

It is time for the international community to put the refugee agenda on the table and start having a very broad discussion about how to address it. (83)

———

The West does not want to accept its responsibility. There are going to be millions of Africans fleeing war. The population is growing, it's going to double, there will be more famine, more wars, and more refugees. This is not just about Syria. Are Western leaders hoping that the problem will just resolve itself? (14)

———

The current-day displacement of people is the largest since the end of World War II. It's a global issue and one that tests the resolve of developed nations to uphold human rights. (84)

———

I am pointing at all the governments who are not really facing up to this humanitarian crisis. It has not ended, it still continues. No nation can separate themselves. (85)

These people have nothing to do with Europe, but they have to come. They have been pushed out, and they are being totally neglected by Europe. They are sleeping in the mud and rain and it is only volunteers giving them food or clothes. (86)

All day long, the media asks me if I have shown the film to the refugees, but that's the wrong question. The purpose is to show it to people of influence; people who are in a position to help and who have a responsibility to help. The refugees who need help—they don't need to see the film. They need dry shoes. They need soup. (87)

———

Especially in today's society, where the power structure has become so complex, it's hard to tell when the interests of certain countries and regimes align. But an individual remains an individual. (88)

———

Any political struggle takes both sides. There are people defending their values and there are people who are trying to take away some of the most important values of our lives. (33)

———

To refuse somebody so desperate is almost a crime. It's immoral, it's shortsighted, and it is not going to benefit this nation. (89)

———

To control the information, to limit the truth: These are most efficient tactics for a totalitarian society. (90)

The United States was basically built by immigrants and refugees. The foundation, the very idea of this nation, was all about everyone being created equal. Violating those ideas to create policies and tactics that push people in need away sets up a very bad situation, not only for the refugees, but for the United States as a nation and how it looks at its own dignity, confidence, and place in the world. (91)

Everyone is a person and has rights; if not, democracy is a lie. (80)

———

Europe and the US have always been very greedy to increase their profit. Their attitude of not wanting to take responsibility shows how cowardly and selfish they are. (92)

———

I think we're lucky that information can be flowing and transmitted through social media in almost real time. We can rally against power. (75)

———

We have to trust in humanity, not politicians.
(86)

———

The internet is the real world. Individuals have never before had a chance to have their voices be heard. The only voice that could be heard, in the past, was from those in power. Now, that's shifting and changing. (93)

———

Many Gulf states refuse refugees, but they have the same religious background and speak the same language. I think this shows very short-sighted politics, like you're refusing to help out your brothers or your relatives. (94)

———

The West exploits Third World countries because many nations in the West are not really defenders of democracy but use it as a cloak, a tool defending their own profit. (17)

—

Internationally, we have many different kinds of systems but all these different powers should have one goal in common: to protect humanity. (84)

—

I don't look at the refugee problem as a regional problem at all, because I think that, after globalization, regional problems are no longer regional. They always reflect some other powers at work. (95)

—

A great nation profits from accepting
difference, from tolerance and understanding.
(32)

––––––

In recent years, after globalization, I think the
political structure and the economic structure
has been dramatically shifting and adjusting
itself. At the same time, the adjustment of our
thinking, or our understanding of the world,
has stayed in old times. (96)

––––––

We no longer want to accept or talk to anyone
who is different, or to try to tolerate or
understand each other. Rather, we are more
exclusive and defensive. And of course
politicians use this kind of danger or risk
to scare people, and to increase
their reputation. (96)

———

I'm not interested in a specific region or one
person or one story. I'm interested in the
global situation. (96)

———

No state or society can claim to have
established human rights once and for all. (97)

———

I think all the far-right movements really show
the nations that lack confidence and lack
an understanding of what humanity
is about. (98)

———

I think the west—generally speaking, the
democratic countries—have benefitted from
a long period of globalization, but they have
also brought a lot of regional instability. The
West should have some vision for dealing
with this. (10)

———

I see how Europe reacted to the refugee crisis.
I think it's shameful, it's questionable, it's
immoral, and in many ways it's not legal. (99)

———

We say that the problem of refugees does not affect us, yet the politics on this issue affects us all. (80)

In politics of course you make a lot of sacrifices, but still you have to defend basic values, otherwise it's not worth being a politician. (36)

It takes global leadership to sit down and see how to prevent refugee situations caused by war, by famine, by environmental problems. There are many things that need to be solved. (100)

Displacement

Every refugee in this world is forced out, like a tree pulled out of the ground by a storm. (59)

———

Most refugees are not seeking money—they're seeking understanding. They have no future.
(101)

———

With all these people, many refugees later become Einstein, Kandinsky, musicians, artists and great scientists. (49)

———

This problem has such a long history, a human history. We are all refugees somehow, somewhere and at some moment. (102)

———

The refugees are very brave. They give up everything, they come to this land. Now in this land, every door is shut. (103)

I became involved with the subject of refugees because I am conscious of how these people have been mistreated, neglected and displaced. I know what it is like to be viewed as an outcast. (84)

I am a refugee, every bit. Those people are me. That's my identity. (87)

My father was exiled and I grew up in the camps. We faced all kinds of discrimination and unfair treatment, so I have a natural understanding of people being seen as different. (105)

I know what it is like to be viewed as a pariah, as sub-human, as a threat and danger to society. (67)

The refugees are brave people who are willing to leave everything they know and go out into the unknown to find better lives. They are not beggars, they have dignity, they have dreams. (91)

The migrants have to go through mountains,
they have to jump into boats—there is no
time to wash. They have to throw away dirty
stuff. There's nothing artistic about it. It's daily
life. It's human struggle. (42)

Almost everyone in America are the children
of immigrants at one point in history, and I
think people should continue to honor,
accordingly, any refugees with the courage
to come to this land. (95)

You see all the refugees we interviewed for
two years now. They're still living in the camp.
You can see the future is very dark. (23)

Most surprising is not that the refugees have
been victimized, but that they're continuously
being victimized when they step into the
so-called safe zone, which is Europe. (105)

———

Who wants to leave their home? Nobody. The
refugees are established, they have their own
neighborhood, they have their career, they
have their language, and they have memories
that no money can buy back. They have
given up everything. (49)

———

I have a natural understanding of people
who are forced to leave their home.
They're constantly feeling uncertainty
and distrust. (106)

———

Most of the refugees come from Syria. Some come from Iraq, Afghanistan or Pakistan. You cannot really track where they are going; they are like water pushed through a pipe, flowing to different locations and destinies. (45)

———

The refugees are transparent, nobody recognizes them even as refugees. (107)

———

As humans, we will never settle. The more intelligent we become, the more motivated we become. (108)

———

These refugees are dealing with this struggle today and probably into the distant future. We see them struggle with their whole hearts and minds, bravely and with imagination, but also with a lot of sorrow and a lot of sadness and a lot of shame. (26)

———

When I first came to Lesbos, we found a half sunken boat there. I asked to be taken to it and sent the other people away. I wanted to experience what it was like to be there alone. I felt what it was like to be on a poorly equipped boat, all by myself, as an insect on a leaf in the middle of the lake. (109)

———

The world has different kinds of refugees.
Some were expelled and had to flee their
country, but many refugees get locked into
a place and will never have the chance
to move freely. (41)

———

The refugees are very brave and capable and
determined to establish a new life. They are
not interested in somebody giving them
mercy or money. They are very proud people
with great dignity. They understand life more
than most people. But who is going to have
them? Or make it possible for them
to restart? (9)

———

Since humans have existed, humans have migrated. It's a major force of civilization. That's how we have become so intelligent, mixed, and more tolerant. (110)

I believe in involvement. Almost every art piece that I've made was shown in places where there are human rights violations. Only by being directly involved in these situations can one change people's minds. (74)

The global so-called current refugee crisis is not so current. Our civilization has always had people moved around, kicked around, rejected, put in desperate situations. (96)

I feel connected to the people who have lost their homes and given up everything, who took their children by the hand and said, "Let's forget everything." It is not an easy decision to go to another country that has another religion, another language. (46)

———

I have so much curiosity. What is it like? Why have they been pushed away? What is the reason for them to give up everything to come to a land where nothing is the same as before: language, race, or religion? (111)

———

Only in the most extreme conditions you see how broken this world is. (35)

———

To be a refugee, by definition, is not because
you're economically poor but because you're
facing danger in your homeland and have
been pushed out. High society persons
can still be refugees. (61)

I think that by using "refugee" as a word, it's
already separating them from normal human
conditions. We always see them as part of the
problem, or a potential problem, or even in
some extreme cases we call them a danger to
our life. This has very much dehumanized
their condition. (37)

Refugees, for me, are not an original problem.
It's a human struggle that has lasted as long as
humans have existed, even before there
were nations. (39)

———

These refugee camps are worse than prisons.
In prison you can do labor, but these people
are invisible. They have no identity, they have
the same story, they have the same past, and
they nearly all have the same future. (112)

Freedom

Freedom only comes from struggle. Liberty is about the fight. We often forget that in prosperous times. (1)

———

We are all people, we have rights, and without them democracy is a lie. (92)

———

People's free will far exceeds the power of the wind, clouds, and rivers. (39)

———

My argument is that water is not political, air is not political, freedom is not political— freedom is necessary for artists. (47)

———

It takes a lot of difficult moments for us to understand and to realize how precious democracy or personal freedom is. (113)

Freedom is not an absolute condition, but a result of resistance. (39)

Human rights and freedom of speech have been a core theme of all my works. (114)

My works are defined by the way they all address the value of human freedom. An individual who stands on this planet, uses his mind, and takes action, can build up communication with others to make change. (114)

———

Freedom never comes into being all by itself. If we stop fighting for it, there will be no freedom. (62)

———

The West always says, "We are free," but that is deceptive. Freedom has to assume responsibility. Freedom needs new goals and new means to achieve them. We need a new language. All this requires commitment on the part of the individual. Without that a society cannot be free. (62)

———

My father was a poet. He brought me up on Whitman, Neruda and Rimbaud. All that made me feel that there was another possibility, and that struggle leads to freedom. That, I think, is the revenge of life. (87)

———

You can never take freedom for granted. It's not possible; it will rot. It rots immediately. (8)

———

I think the internet is like a modern church. In a church, you worship the divine, but people on the internet worship individualism and freedom of speech. (47)

———

I am eager to understand how the values that form the foundation of democracy and freedom are protected, and how they have been violated. To become involved—to take a personal journey to better understand the historical context, the current situation, and what is possible in the future—is the most natural act for an artist like me. (84)

———

The regime is afraid of freedom, and art is about freedom. (90)

———

With no freedom of speech, the world can be horrifying. (17)

If you don't have freedom of speech, you don't have freedom of expression, then all your creativities are shadowed. (111)

We have become accustomed to taking democracy and freedom for granted. (54)

If a place stands for democracy and for the right to free speech, and if it protects human dignity, then it can be my home. (54)

I have no anger at all. All my difficulties have given treasure to my life. They challenged me and made me look at things differently. Even the people who put me in such difficult conditions were acting as humans. (3)

People want their story to be told. They've been neglected for too long and their voices cannot be heard. (111)

Where is democracy? Where is personal freedom? Where is our belief that we can build a better society? It takes every individual to get involved. (61)

We can accept anything if we don't accept defending humanity, defending freedom of speech. Then we can accept dictatorship, slavery, mafias, anything. (38)

―――――

Life does not originally take a form of freedom; only through the process of resistance does this form take shape. (39)

―――――

We all understand that, without an individual's involvement, the words "civil liberty" are empty and freedom for any society cannot be achieved. (39)

Action

The silence of the 65 million refugees is a humiliation for those of us with a voice. (80)

———

This is a human-created problem. Humans created it, so we must solve it. (16)

———

It's never too late to do something. (20)

———

We all have to understand that humanity, and liberty, needs to be defended by each generation. (115)

———

I don't care what people think. My work belongs to the people who have no voice. (116)

———

We're spoiled by contemporary life; we forget
other people still in suffering and in pain and
who need help. (117)

If you look away, you are complicit. (43)

As long as someone fights and helps, the fight
is not lost. (46)

It is the duty of an artist to connect himself or
herself to social change, to bear responsibility,
to be part of the change. (118)

I want people to be emotionally involved.
The hope is for individuals to realize these
refugees relate to our normal life and that we
have a responsibility to act. (31)

To live so comfortably while other people are
in desperate situations, that surprises me. It's
not a refugee problem. It's a human crisis, and
it includes the people that can help but
don't help. (119)

We have to protect other people just like we
have to protect ourselves. Otherwise, anyone
can be refugees. (117)

This is a very historical moment from any perspective. As an artist I want to be more involved, I want to create artworks in relation to the refugee crisis and create some kind of consciousness about the situation. (120)

If we're not happy with the way things are, we should do something to create a better world for our children. Otherwise parenthood is a joke. (47)

Even if I gave all of my money to the refugees, it would not help them. But spreading knowledge—letting other people know what's happening—I think that is most important.

(121)

You really have to be emotionally and physically involved, otherwise you become superficial and you just sit in your own little world and read the news. (26)

We have to understand that the situation is not really about refugees. It is about all of us. I think the solution takes individuals to act, to be involved, to push the politicians, to create the right discussion. We can all start from ourselves. (51)

If you want to do something, today there are a million ways to do it with the internet. We can find a community or a non-governmental organization or volunteers who are working on the front line in extremely difficult conditions. (122)

It's very important to do something, like a documentary or something on the internet. These things, like weather, gradually change the temperature and will build some kind of movement. (81)

I don't need anything. I just want to burn myself out. It's life; you better use it. (123)

Today, I still have a big voice in talking about human rights and freedom of speech. I hope I can create a better condition for my son's generation so that he doesn't have to put up the same kind of fight as his father and his grandfather did. (93)

———

Art has to be involved with moral, philosophical, and intellectual conversations. If you call yourself an artist, this is your responsibility. (124)

———

The politicians are the ones who we think can make some difference. But of course they will not make a difference if the citizens or the individuals do not push them or speak out. This is not acceptable. (23)

———

We have to remember we have no choice. We're either on the right side or on the wrong side. (105)

———

Be more involved. Take responsibility. Provide yourself opportunities at the same time that you provide opportunities to others. (1)

———

Today, I feel that as an individual I must make an effort to make people more conscious that refugees are not different from us in any way. They are not terrorists, and to portray them as such is really terroristic thinking. They are just human beings and their pain, their joy, their sense of safety, and sense of justice is no different from ours. (83)

———

The refugee crisis is a human crisis. We all have a responsibility in this. (125)

———

I had to be there or else I would be speechless.
I would not be entitled to talk about the
situation because I wouldn't know it. I had to
meet the refugees, I had to look at them face-
to-face, ask them questions, make some jokes
with them: it's the only way to understand the
situation. Otherwise I would be scared or mad
or threatened for the rest of my life. (4)

You realize how all these refugees are being
humiliated and vilified. If you have a
conscience, you react to this state of
affairs. (126)

It's just the persistence to still take one more
step. And one more step. (127)

If you feel, "This is senseless," then you shut off because the crisis is getting too big, you cannot do anything about it. That is the most dangerous moment. (128)

———

I try to look at change from an ecological or biochemical point of view. It's like cells mutating. Very small individual changes can lead to social change. (129)

———

The only reason the crisis exists today is because people don't act, because they've given up their right to act. This has become a real potential crisis in humanity: the one who's privileged refusing to act. (122)

———

During change, human rights, human dignity
and free speech have to be protected.
Otherwise, we'll be going backward. (60)

If you can, you have to help. (46)

I feel powerful when I'm defending essential
values such as human rights. But these things
require everybody to act. (130)

How many times do people shrug their shoulders and say, "What can we do?" A society is always composed of groups of individuals. You can influence other people and make your voice heard. It would be a shame if we had to confess to our children that we did nothing. That we pretended that we knew nothing. Or that we had no power. Come on! We have great power. (54)

———

These are not tragedies, but man-made consequences of war. If we continue to deliver weapons to these areas, if we blaze those wars, refugees are the result. And I've tried to find a language to make those who otherwise have no voice be heard. And to be heard by those who are so often deaf. People often feel that the refugees have nothing to do with their lives at all. It's all so far away. So they turn their faces away. My job is to turn your gaze. (131)

———

It takes individuals to have a voice, to push the political leaders. (132)

———

I feel optimistic because if you see human development it always comes from struggles, and that struggle takes a lot of individuals to become conscious and to act. (132)

———

We all have a short life. We have only a moment to speak out or to use what little skills we have. If everybody does that, maybe the temperature changes. (87)

———

I wanted to do anything possible to not only support and honor the people who are still living and who have died, but as a reminder that this is something happening all over the world. (125)

———

I think in a civil society, everybody needs
to act. (37)

———

It's in my blood to try to be different, or to try
to create my own form or language, to define
my world. (39)

———

Indifference does not liberate us, but instead
cuts us off from reality. (39)

SOURCES

Quotations presented in the text have in some cases been lightly edited for clarity.

1. Thomas, M. "Ai Weiwei speaks in Pittsburgh about life and art." *Pittsburgh Post-Gazette*, June 5, 2016. http://www.post-gazette.com/ae/art-architecture /2016/06/05/Ai-Weiwei-speaks-in-Pittsburgh-about -life-and-art-1/stories/201606040139

2. AFP. "'Anybody could be a refugee': Ai Weiwei films global crisis." *Daily Mail*, February 23, 2017. http://www.dailymail.co.uk/wires/afp/article-4251578 /Anybody-refugee-Ai-Weiwei-films-global-crisis.html

3. Sooke, Alastair. "Ai Weiwei interview: 'I am the best selfie artist.'" BBC, September 18, 2017. http:// www.bbc.com/culture/story/20170918-ai-weiwei -interview-i-am-the-best-selfie-artist

4. Ehrlich, David. "How 'Human Flow' Director Ai Weiwei Made the Definitive Film About the Refugee Crisis." *Indie Wire*, October 18, 2017. http://www.indiewire.com/2017/10/ai-weiwei-human-flow-documentary-interview-refugee-crisis-1201887125/

5. CBC Arts. "Ai Weiwei: How to change the world in 3 easy steps." *CBC*, November 15, 2016. http://www.cbc.ca/arts/ai-weiwei-how-to-change-the-world-in-3-easy-steps-1.3850739

6. Ostwald, Susanne. "Das Schöne und das Dunkle existieren in demselben Bild." *Neue Zürcher Zeitung*, November 14, 2017. https://www.nzz.ch/feuilleton/das-schoene-und-das-dunkle-existieren-in-demselben-bild-ld.1326643

7. Suhrawardi, Rebecca. "Chinese Activist Ai Weiwei Returns to New York with Four Refugee-Focused Exhibitions." *Forbes*, November 5, 2016. https://www.forbes.com/sites/rebeccasuhrawardi/2016/11/05/chinese-activist-ai-weiwei-returns-to-new-york-with-four-refugee-focused-exhibitions/#3c25765238ba

8. Gelman Myers, Judy. "Call for Action: Chinese artist Ai Weiwei's 'Human Flow' documents worldwide

refugee crisis." *Film Journal International*, October 11, 2017. http://www.filmjournal.com/features/call -action-chinese-artist-ai-weiweis-human-flow-documents -worldwide-refugee-crisis

9. Kramer, Gary M. "'We could all be potential refugees': Ai Weiwei on the epic journey of 'Human Flow.'" *Salon*, October 14, 2017. https://www.salon .com/2017/10/14/we-could-all-be-potential-refugees -ai-weiwei-on-the-epic-journey-of-human-flow/

10. Whyte, Murray. "Ai Weiwei turns his lens on refugee crisis." *The Star*, October 19, 2017. https:// www.thestar.com/entertainment/visualarts/2017/10/19 /ai-weiwei-turns-his-lens-on-refugee-crisis.html

11. "Ai Weiwei 'Laundromat.'" *NY Art Beat*. http://www .nyartbeat.com/event/2016/AB9C

12. AP. "Ai Weiwei puts human face on migrant crisis in 'Human Flow.'" September 1, 2017. http://www .breitbart.com/news/ai-weiwei-puts-human-face-on -migrant-crisis-in-human-flow/

13. AP. "Ai Weiwei sets up studio on Greek island to highlight plight of refugees." *Guardian*, January 1, 2016. https://www.theguardian.com/artanddesign

/2016/jan/01/ai-weiwei-sets-up-studio-on-greek
-island-of-lesbos-to-highlight-plight-of-refugees

14. Cué, Carlos E. "Ai Weiwei: 'Humanity is more
cowardly with each passing day.'" *El País*, August 3,
2017. https://elpais.com/elpais/2017/08/02/inenglish
/1501684675_384911.html

15. Eisinger, Dale. "Ai Weiwei's *Good Fences Make Good
Neighbors* Tests the Limits of Humanity." *Spin*,
October 23, 2017. https://www.spin.com/2017/10
/ai-weiwei-good-fences-make-good-neighbors-review/

16. Urist, Jacoba. "How Should Art Address Human
Rights?" *The Atlantic*, April 4, 2017. https://www
.theatlantic.com/entertainment/archive/2017/04
/how-should-art-address-human-rights/521520/

17. Jayaraman, Gayatri. "Artist awash in the land of
refugees." *India Today*, February 3, 2016. http://
indiatoday.intoday.in/story/ai-weiwei-tribute-to-syrian
-refugee-aylan-kurdi/1/587095.html

18. Wiener, Jon. "Ai Weiwei on the Refugee Crisis:
'People Have Been Forced Into a State of Move-
ment.'" *Start Making Sense: The Nation's Podcast*,
October 13, 2017. https://www.thenation.com

/article/ai-weiwei-on-the-refugee-crisis-people
-have-been-forced-into-a-state-of-movement/

19. Beam, Christopher. "Beyond Ai Weiwei: How
China's Artists Handle Politics (Or Avoid Them)."
New Yorker, March 27, 2015. https://www
.newyorker.com/news/news-desk/ai-weiwei-problem
-political-art-china

20. Anderson, Ariston. "Venice: 'Human Flow' Director
Ai Weiwei on the 'Moral Challenge' of the Refugee
Crisis." *Hollywood Reporter*, September 1, 2017.
http://www.hollywoodreporter.com/news/venice
-human-flow-director-ai-weiwei-moral-challenge-refugee
-crisis-1034542

21. Pham, Sherisse. "Artists Ai Weiwei and Anish
Kapoor: March for refugees." CNN, September 21,
2015. http://www.cnn.com/2015/09/17/world
/ai-weiwei-anish-kapoor-march-for-refugees/index.html

22. Flak, Agnieszka, and Hanna Rantala. "Ad-hoc
iPhone shots inspired refugee epic, Chinese artist
says." *Reuters*, September 1, 2017. https://news.trust
.org/item/20170901150547-ilnrs

23. Glasser, Susan B. "China Is Laughing About This
Situation." *Global Politico*, October 16, 2017. http://

www.politico.com/magazine/story/2017/10/16
/ai-weiwei-global-politico-transcript-215715

24. "Ai Weiwei's 'Good Fences Make Good Neighbors.'"
 CBS News, October 15, 2017. https://www
 .cbsnewscom/news/ai-weiweis-good-fences-make
 -good-neighbors/

25. Luscombe, Belinda. "7 Questions With Ai Weiwei."
 Time, October 12, 2017. http://time.com/4979256
 /ai-weiwei-new-york-exhibiton/

26. Combemale, Leslie. "Human Flow Review and
 Exclusive Interview with World Renowned Artist Ai
 Weiwei." *Cinema Siren*, October 13, 2017.
 http://cinemasiren.com/cinema-siren/human-flow
 -review-exclusive-interview-world-renowned-artist
 -ai-weiwei/

27. Suhrawardi, Rebecca. "Chinese Activist Ai Weiwei
 Returns to New York with Four Refugee-Focused
 Exhibitions." *Forbes*, November 5, 2016. https://
 www.forbes.com/sites/rebeccasuhrawardi/2016/11/05
 /chinese-activist-ai-weiwei-returns-to-new-york-with
 -four-refugee-focused-exhibitions/#3c25765238ba

28. Stewart, Jessica. "Ai Weiwei Draws Attention to the
 Refugee Crisis with Powerful New Installation." My

Modern Met, March 20, 2017. http://mymodernmet
.com/ai-weiwei-law-of-the-journey/

29. Shah, Vikas. "A Conversation With Ai WeiWei—Art-
 ist & Activist." *Thought Economics*, June 28, 2017.
 https://thoughteconomics.com/ai-weiwei-interview/

30. Dick, Jason. "Ai Weiwei Brings Politics, Humanity
 to 'Human Flow.'" *Roll Call*, October 11, 2017.
 https://www.rollcall.com/news/politics/ai-weiwei
 -brings-politics-humanity-human-flow

31. Vankin, Deborah. "Why Ai Weiwei was compelled
 to take on the global refugee crisis in his new
 documentary." *Los Angeles Times*, October 6, 2017.
 http://www.latimes.com/entertainment/arts/la-ca
 -mn-ai-weiwei-human-flow-20171006-htmlstory.html

32. Ziv, Stav. "Trump's 'ridiculous' border wall, travel
 ban will not make America great again, Ai Weiwei
 says." *Newsweek*, October 14, 2017. http://www
 .newsweek.com/2017/10/27/trumps-ridiculous-border
 -wall-travel-ban-will-not-make-america-great-again-ai
 -684733.html

33. AP. "Chinese dissident artist Ai Weiwei: Trump 'has
 to be challenged.'" *The Asahi Shimbun*, June 2, 2017.
 http://www.asahi.com/ajw/articles/AJ201706020024
 .html

34. Poulou, Penelope. "'Human Flow' Film Documents Refugees' Troubles." *VOA*, November 2, 2017. https://learningenglish.voanews.com/a/human-flow-film-documents-refugees-troubles/4089396.html

35. "Ai Weiwei: Refugee camps show 'how broken this world is.'" BBC, August 11, 2016. http://www.bbc.com/news/av/world-africa-37045319/ai-weiwei-refugee-camps-show-how-broken-this-world-is

36. PA. "Ai Weiwei: Politicians must consider the humanity of migrants." BT, December 4, 2017. http://home.bt.com/news/showbiz-news/ai-weiwei-politicians-must-consider-the-humanity-of-migrants-11364234505714

37. Snow, Jon. "Ai Weiwei directs film on migrant crisis." *Channel 4 News*, December 4, 2017. https://www.channel4.com/news/ai-weiwei-directs-film-on-migrant-crisis

38. Siegal, Nina. "Ai Weiwei Speaks Out Against Donald Trump's Wall and Other Borders." *Blouin Art Info*, November 30, 2017. http://www.blouinartinfo.com/news/story/2694535/ai-weiwei-speaks-out-against-donald-trumps-wall-and-other

39. Chen, Lux, and Cynthia Rowell. "The Art of Activism: An Interview with Ai Weiwei on 'Human Flow.'" *Cineaste*, October 2017.

40. Farrell, Aimee. "15 Minutes With Ai Weiwei." *T Magazine*, June 17, 2016. https://www.nytimes.com/2016/06/16/t-magazine/ai-weiwei-trees-cambridge.html

41. "Ai Weiwei Drifting." *DW*, June 21, 2017. https://www.youtube.com/watch?v=9MkcTI00_uw

42. Pogrebin, Robin. "Ai Weiwei Melds Art and Activism in Shows About Displacement." *New York Times*, October 20, 2016. https://www.nytimes.com/2016/10/21/arts/design/ai-weiwei-melds-art-and-activism-in-shows-about-displacement.html?_r=5

43. Jungen, Christian. "Ich strebe nach Wahrheit." *NZZam Sonntag*, November 4, 2017. https://nzzas.nzz.ch/kultur/ai-weiwei-ich-strebe-nach-wahrheit-ld.1326289

44. Kane, Peter Lawrence. "Ai Weiwei and the crisis of Our Time." *SF Weekly*, October 11, 2017. http://www.sfweekly.com/culture/film-culture/ai-weiwei-and-the-crisis-of-our-time/

45. Goncharova, Masha. "On Instagram, the Artist Ai Weiwei Focuses on Refugees." *New York Times*, August 18, 2016. https://www.nytimescom /2016/08/18/travel/on-instagram-the-artist-ai-weiwei -focuses-on-refugees.html

46. Von Hof, Elisa. "Ai Weiwei: 'Wenn du kannst, musst du helfen.'" *Berliner Morgenpost*, October 11, 2017. https://www.morgenpost.de/kultur/article 212435363/Wenn-du-kannst-musst-du-helfen.html

47. Wallace-Thompson, Anna. "Chinese Dissident Artist Ai Weiwei on Responding to the Syrian Refugee Crisis and His New Life in Berlin." *Artsy*, February 8, 2016. https://www.artsy.net/article/artsy-editorial -ai-weiwei-speaks-about-his-divisive-responses-to-the -syrian-refugee-crisis-lego-and-his-new-life-in-berlin

48. Phong Bui. "Ai Weiwei with Phong Bui." *The Brooklyn Rail*, December 6, 2016. http://brooklyn rail.org/2016/12/art/ai-weiwei

49. Minow, Nell. "Ai Weiwei on 'Human Flow,' Refugees, and Countries Who Won't Let Them In." *Huffington Post*, October 9, 2017. https://www.huffing tonpost.com/entry/ai-weiwei-on-human-flow-refugees -and-countries_us_59dac617e4b0cf2548b33887

50. Tan, Monica. "Ai Weiwei poses as drowned Syrian infant refugee in 'haunting' photo." *Guardian*, January 31, 2016. https://www.theguardian.com /artanddesign/2016/feb/01/ai-weiwei-poses-as -drowned-syrian-infant-refugee-in-haunting-photo

51. Aftab, Kaleem. "Ai Weiwei's tribute to a flowing tide of humanity opens in Venice." *The National*, September 4, 2017. https://www.thenational.ae /arts-culture/ai-weiwei-s-tribute-to-a-flowing-tide -of-humanity-opens-in-venice-1.625605

52. Duponchelle, Valérie. "Ai Weiwei: 'Je pourrais exposer dans une prison ou un supermarché.'" *Le Figaro*, January 19, 2016. http://www.lefigaro .fr/arts-expositions/2016/01/19/03015 -20160119ARTFIG00059-ai-weiweije-pourrais -exposer-dans-une-prison-ou-un-supermarche.php

53. Poulou, Penelope. "Ai Weiwei's 'Human Flow' Highlights Refugee Plight Around the World." *VOA*, October 18, 2017. https://www.voanews.com/a /ai-weiwei-on-human-flow-documentary/4076059.html

54. "Der Menschenwürde ein Gesicht geben." *Rhein-Neckar-Zeitung*, November 11, 2017. https://

www.rnz.de/panorama/rnz-leute_artikel,-kuenstler
-ai-weiwei-der-menschenwuerde-ein-gesicht-geben
-_arid,315426.html

55.	Riefe, Jordan. "How Documentaries Are Combating
	'Deafening Silence' on Human Rights Crises."
	Hollywood Reporter, November 9, 2017. http://www.
	hollywoodreporter.com/news/how-documentaries
	-are-combating-deafening-silence-human-rights-crises
	-1054878

56.	Kinosian, Janet. "Director Ai Weiwei's 'Human Flow'
	finds the deep humanity in overwhelming refugee
	crisis." *Los Angeles Times*, November 9, 2017. http://
	www.latimes.com/entertainment/envelope
	/la-en-mn-1109-human-flow-20171108-story.html

57.	Macnab, Geoffrey. "Ai Weiwei: my 'Human Flow'
	profits will go to refugee NGOs.'" *Screen Daily*,
	September 2, 2017. https://www.screendaily.com
	/features/ai-weiwei-my-human-flow-profits-will-go-to
	-refugee-ngos/5121909.article

58.	Art Daily. "Major artists donate works for auction in
	support of Help Refugees." *Art Daily*. http://artdaily

.com/news/100740/Major-artists-donate-works-for
-auction-in-support-of-Help-Refugees#.WiruJrQ-dE4

59. MacKenzie, Steven. "Ai Weiwei: 'The only conclusion is that there is a lot of inhumanity in us." *The Big Issue*, December 11, 2017. https://www.bigissue
.com/news/ai-weiwei-conclusion-lot-inhumanity-us/

60. Miles, Kathleen. "Ai Weiwei: Nationality And Borders Are Barriars To Our Intelligence And Imagination." *Huffington Post*, September 7, 2017.
https://www.huffingtonpost.com/entry/ai-weiwei
-documentary_us_59ac0653e4b0b5e530ff42cd?ncid=en
gmodushpmg00000004

61. "We have to focus on humanity." *Zweites Deutsches Fernsehen*, November 11, 2017. https://www.zdf.de
/kultur/aspekte/ai-weiwei-interview-100.html

62. "Because life is short and transitory: Interview with Ai Weiwei." Web Video, *DW News*, September 6, 2017. http://www.dw.com/en/because-life-is-short-and
-transitory-interview-with-ai-weiwei/av-39183855

63. Neuendorf, Henri. "Ai Weiwei Sets Up Lesbos Studio and Calls for Monument Dedicated to Refugees." *Artnet News*, January 4, 2016. https://

news.artnet.com/art-world/ai-weiwei-lesbos-studio
-monument-refugees-401285

64. Yam, Kimberly. "Ai Weiwei Believes The U.S. Has Hit
 A Low When It Comes To Human Rights." *Huffington
 Post*, October 16, 2017. https://www
 .huffingtonpost.com/entry/ai-weiwei-human-flow_us
 _59dbe51ce4b0b34afa5b9b75

65. Swift, Hilary, Jean Yves Chainon, and Kaitlyn
 Mullin. "Ai Weiwei Puts Up Fences to Promote
 Freedom." *New York Times*: The Daily 360. https://
 www.nytimes.com/video/arts/100000005490574
 /ai-weiwei-puts-up-fences-to-promote-freedom.html

66. "Kunst kann die Welt verändern." *RP Online*,
 November 4, 2017. http://www.rp-online.de
 /panorama/wissen/kunst-kann-die-welt-veraendern
 -aid-1.7180065

67. Demick, Barbara. "Dissident Chinese artist Ai
 Weiwei finds home too dangerous, but he may go
 to Syria." *Los Angeles Times*, December 18, 2016.
 http://www.latimes.com/nation/la-fg-china-ai-weiwei
 -2016-story.html

68. Bechiri, Holly. "World-renowned artist Ai Weiwei brings conversations of freedom, nature, state to Grand Rapids." *Cultured GR*, January 12, 2017. http://www.mlive.com/entertainment/grand-rapids/index.ssf/2017/01/world-renowned_artist_ai_weiwei.html

69. Forrest, Nicholas. "Ai Weiwei Announces Provocative NY Public Art Fund Project." *Blouin Art Info*, March 27, 2017. http://www.blouinartinfo.com/news/story/2043866/ai-weiwei-announces-provocative-ny-public-art-fund-project

70. AP. "The Latest: Chinese artist Ai Weiwei visits border camp." *AP News*, March 9, 2016. https://apnews.com/5d8e0a68866d44688439c1a6e0be243d/latest-more-migrants-come-greek-macedonian-border

71. Goodman, Amy. "'Human Flow': World-Renowned Artist & Activist Ai Weiwei on His Epic New Documentary on Refugees." *Democracy Now!*, October 9, 2017. https://www.democracynow.org/2017/10/9human_flow_world_renowned_artist_activist

72. Pollack, Barbara. "Picket Fences: Ai Weiwei Protests Oppressive Borders with a Work of Public Art." *Artnews*, September 26, 2017. http://www.artnews.com/2017/09/26/picket-fences-ai-weiwei-protests-oppressive-borders-with-a-work-of-public-art/

73. Lesser, Casey. "Ai Weiwei Installs Fences across New York, Making Locals Face the Refugee Crisis." *Artsy*, October 11, 2017. https://www.artsy.net/article/artsy-editorial-ai-weiwei-installs-fences-new-york-making-locals-face-refugee-crisis

74. Alexander, Neta. "Ai Weiwei: The New Fences and Walls Betray the World's Sagging Courage." *Haaretz*, October 17, 2017. http://archive.isbZzuh#selection-2861.143–2864.0

75. Riefe, Jordan. "Artist Ai Weiwei on Ingredients for Effective Activism." *Truth Dig*, October 14, 2017. https://www.truthdig.com/articles/artist-ai-weiwei-ingredients-effective-activism/

76. Wong, Ali. "What we learned from Ai Weiwei's discussion with Jon Snow." *Dazed Digital*, December 6, 2017. http://www.dazeddigital.com/politics

/article/38319/1/what-we-learned-from-ai-weiweis
-discussion-with-jon-snow

77. Offenhartz, Jake. "Ai Weiwei Previews His Expansive Citywide Exhibition." *Gothamist*, October 11, 2017. http://gothamist.com/2017/10/11/ai_weiwei _previews_his_controversia.php#photo-1

78. "My Virtual Life Has Become My Real Life." *Spiegel*, January 15, 2014. http://www.spiegel.de /international/world/chinese-artist-ai-weiwei-discusses -efforts-in-china-to-monitor-him-a-943719.html

79. Siegler, Mara. "Ai Weiwei thinks Trump's stance on immigration is 'outrageous.'" *Page Six*, October 10, 2017. https://pagesix.com/2017/10/10/ai-weiweis -public-art-installation-is-dedicated-to-refugees/

80. Carracedo, Benito. "Weiwei insta a gritar por los refugiados." *Dario de Valladolid*, October 24, 2017. http://www.diariodevalladolid.es/noticias/valladolid /weiwei-insta-gritar-refugiados_101531.html

81. "Human Flow: Interview with Chinese Artist-Activist Ai Weiwei." *Emanuel Levy*, October 16, 2017. http://emanuellevy.com/review/featured-review /human-flow-interview-with-chinese-artist-activist -ai-weiwei/

82. AFP. "Ai Weiwei slams 'shameful' politicians ignoring refugees." *Art Daily*. http://artdaily.com /news/94514/Ai-Weiwei-slams—shameful—politicians -ignoring-refugees#.WepcXLzytE6

83. "Human Flow" Production Notes. https://www.humanflow.com/press-kit/

84. Vivarelli, Nick. "Chinese Artist Ai Weiwei Talks migrant Crisis Doc 'Human Flow' Ahead of Venice Premiere." *Variety*, August 25, 2017. http://variety .com/2017/film/global/chinese-artist-ai-weiwei-on -his-migrant-crisis-doc-human-flow-ahead-of-venice -world-premiere-exclusive-1202538890/

85. Crouch, David. "Ai Weiwei shuts Danish show in protest at asylum-seeker law." January 27, 2016. https://www.theguardian.com/artanddesign/2016 /jan/27/ai-weiwei-shuts-danish-show-in-protest -at-asylum-seeker-law

86. Brown, Mark. "Ai Weiwei says EU's refugee deal with Turkey is immoral." *Guardian*, May 19, 2016. https://www.theguardian.com/world/2016/may/19 /ai-weiwei-chinese-artist-eu-refugees-turkey -immoral-humanitarian-crisis-lesbos

87. Brooks, Xan. "'Without the prison, the beatings, what would I be': The g2 interview." *The Guardian*, September 18, 2017, pp. 4–7.

88. Zhuo-Ning Su. "Venice Dispatch – Interview with Ai Wei Wei (Human Flow)." *Awards Daily*, August 31, 2017. http://www.awardsdaily.com/2017/08/31 /venice-dispatch-interview-ai-wei-wei-human-flow/

89. AP. "Chinese artist Ai Weiwei brings new refugee-themed piece to Prague." CBC, March 17, 2017. http://www.cbc.ca/news/entertainment/ai-weiwei -refugee-art-prague-1.4029979

90. Williams, Holly. "How Chinese Artist Ai Weiwei became an enemy of the state." CBS, May 21, 2017. https://www.cbsnews.com/news/ai-weiwei-how -chinese-artist-became-an-enemy-of-the-state/

91. Miller, Danny. "Interview: Ai Weiwei Urges a More Compassionate View of the Global Refugee Crisis in 'Human Flow.'" *Cinephiled*, October 24, 2017. http://www.cinephiled.com/interview-ai-weiwei-urges -compassionate-view-global-refugee-crisis-human-flow/

92. Ors, Javier. "Ai Weiwei: 'Me identifico con los niños refugiados.'" *La Razón*, October 24, 2017. http://www.larazon.es/cultura/ai-weiwei-me-identifico-con-los-ninos-refugiados-HG16670171

93. Wong, Jessica. "Ai Weiwei on refugees, empathy and the 'miracle' of the internet." *CBC*, September 27, 2017. http://www.cbc.ca/news/entertainment/ai-weiwei-invu-1.4309871

94. Finn, Tom. "Ai Weiwei calls on Gulf states to do more to help Syrian refugees." *Reuters*, April 12, 2017. http://www.reuters.com/article/us-mideast-crisis-gulf-aiweiwei/ai-weiwei-calls-on-gulf-states-to-do-more-to-help-syrian-refugees-idUSKBN17E195

95. Karpan, Andrew. "Ai Weiwei on 'Human Flow,' the Refugee Crisis and Increased Human Selfishness." *Nonfics*, October 16, 2017. https://nonfics.com/ai-weiwei-human-flow-interview-55477e19e525

96. Cooper, Zoe. "Artist and activist Ai Weiwei on exploring the absurdity of national border." *Vox*, November 3, 2017. https://www.vox.com/conversations/2017/11/3/16601358/aiweiwei-artist-borders-human-flow-documentary

97. Zand, Bernhard. "The State Is Scared." *Spiegel*, May 20, 2015. http://www.spiegel.de/international/world /spiegel-interview-with-chinese-artist-ai-weiwei -a-1034661.html

98. Szklarski, Cassandra (The Canadian Press). "Ai Weiwei praises Canada for having a 'very open attitude' towards refugees." *CTV News*, September 28, 2017. http://www.ctvnews.ca/entertainment /ai-weiwei-praises-canada-for-having-a-very-open -attitude-towards-refugees-1.3610991

99. "Ai Weiwei's Greek show highlights shameful response to refugee crisis." *The Daily Herald*, May 20, 2016. https://www.thedailyherald.sx/people /57544-ai-weiwei-s-greek-show-highlights-shameful -response-to-refugee-crisis

100. Mottram, James. "Ai Weiwei, interview: 'I identify with refugees … I can talk to them, cut their hair, eat with them." *i news*, November 30, 2017. https:// inews.co.uk/essentials/ai-weiwei-interview-i -identify-refugees-i-can-talk-cut-hair-eat/

101. Wilson, Emily. "Ai Weiwei Talks Global Refugee Crisis & New Film in San Francisco." *Broke-Ass Stuart*, October 6, 2017. http://brokeassstuart.com /blog/2017/10/06/ai-weiwei-talks-global-refugee-crisis -new-film-san-francisco/

102. Brown, Mark. "Ai Weiwei and Anish Kapoor lead London walk of compassion for refugees." *Guardian*, September 17, 2015. https://www .theguardian.com/uk-news/2015/sep/17/ai-weiwei -anish-kapoor-london-walk-refugees

103. "Ai Weiwei: Europe not giving refugees dignity or love." *Al Jazeera*, March 10, 2016. http://www .aljazeera.com/news/2016/03/ai-weiwei-europe-giving -refugees-dignity-love-160310131127940.html

104. Smith, Mike (AFP). "For Trump, a 'brand' for global trend toward hate." *The Nation*, June 3, 2017. http:// www.nationmultimedia.com/news/opinion /30317097

105. Szklarski, Cassandra (The Canadian Press). "Chinese artist and dissident Ai Weiwei turns eye to refugee crisis." *CTV News*, September 28, 2017. http://

www.ctvnews.ca/entertainment/chinese-artist-and
-dissident-ai-weiwei-turns-eye-to-refugee-crisis
-1.3636102

106. "Ai Weiwei captures the global refugee crisis in
'Human Flow.'" *PBS*, October 20, 2017. https://
www.pbs.org/newshour/show/ai-weiwei-captures-the
-global-refugee-crisis-in-human-flow

107. EFE. "Ai Weiwei: 'La crisis de refugiados es una
crisis moral." *El Nuevo Herald*, October 20, 2017.

108. Anderson, Ariston. "'As Humans, We Will Never
Settle': Five Questions for 'Human Flow' Director Ai
Weiwei." *Filmmaker Magazine*, October 13, 2017.
http://filmmakermagazine.com/103538-as-humans-we
-will-never-settle-five-questions-for-human-flow-director
-ai-weiwei/#.WekSi7zytE5

109. AFP. "Giant Ai Weiwei refugee installation to go on
display in Prague." *The Nation*, March 11, 2017.
http://www.nationmultimedia.com/news/life/art
_culture/30308674

110. Buder, Emily. "Humanity Is Subjective." The *Atlantic*, October 14, 2017. https://www.theatlantic .com/entertainment/archive/2017/10/ai-wei-wei -human-flow/542556/

111. "WETA Arts 511." *WETA*, November 10, 2017. http://watch.weta.org/video/3006494340/

112. Pape, Stefan. "Ai Weiwei on documenting the 'greatest global crisis since World War Two.'" Little White Lies, December 8, 2017. http://lwlies.com /articles/ai-weiwei-human-flow-global-migrant-crisis/

113. "Ai Weiwei at Hirshhorn: Demetrion Lecture." *Hirshhorn Museum Youtube Channel*, July 6, 2017. https://www.youtube.com/watch?v=hmH4ckTNHkQ&t =916s

114. Havis, Richard James. "Chinese artist Ai Weiwei on the importance in Trump era of his art inspired by refugee crisis, now on show in streets of New York." *South China Morning Post*, October 14, 2017. http://www.scmp.com/culture/arts -entertainment/article/2115200/chinese-artist-ai-weiwei -importance-trump-era-his-art

115. "Exclusive interview with Ai Weiwei on his new documentary 'Human Flow.'" *TRT World*, October 16, 2017. https://www.youtube.com/watch?v=iS5fc1D4AeI

116. Faiola, Anthony. "In Europe, the refugee crisis as art: 14,000 bright orange life jackets." *The Washington Post*, February 15, 2016. https://www.washingtonpost.com/world/in-europe-the-refugee-crisis-as-art-14000-bright-orange-life-jackets/2016/02/15/d6d23c50-d3f5-11e5-a65b-587e721fb231_story.html?utm_term=.7ae5f9fc5cdc

117. Eckardt, Stephanie. "At the Controversial Center of Ai Weiwei's Great Wall of Art in New York, the Dissident Artist Is Selfie-Obsessed and Self-Reflective." *W Magazine*, October 13, 2017. https://www.wmagazine.com/story/ai-weiwei-nyc-washington-square-public-art

118. McGlone, Peggy. "Ai Weiwei on creating political art in the Trump era: 'Be part of the change.'" *The Washington Post*, June 27, 2017. https://www.washingtonpost.com/entertainment/museums/ai

-weiwei-on-creating-political-art-in-the-trump-era
-be-part-of-the-change/2017/06/27/ecf65e64-5a98
-11e7-a9f6-7c3296387341_story.html?utm_term=
.a70948cbc501

119. Keating, Joshua. "Ai Weiwei on His Experimental
New Doc About the Refugee Crisis and Why It's
Our Crisis, Too." *Slate*, October 9, 2017.
http://www.slate.com/blogs/browbeat/2017/10/09
/ai_weiwei_on_his_new_refugee_crisis_doc_human
_flow.html

120. Nordstrom, Louise. "Chinese artist's refugee
memorial 'can help put spotlight on crisis.'" *France
24*, January 2, 2016. http://www.france24.com
/en/20160102-ai-weiwei-refugees-crisis-greece
-lesbos-memorial-deaths-art-migrants

121. Cohen, Jerome A. "A Conversation With Ai Weiwei."
Council of Foreign Relations, November 2, 2016.
https://www.cfr.org/event/conversation-ai-weiwei

122. Kilkenny, Katie. "'Being a refugee is a human
condition': An Interview with Ai Weiwei." *Pacific
Standard*, October 6, 2017. https://psmag.com
/social-justice/an-interview-with-ai-weiwei

123. Desmarais, Charles. "Chinese artist Ai Weiwei switches media to make documentary on refugees." *San Francisco Chronicle*, October 17, 2017. http://www.sfchronicle.com/news/article/Chinese-artist-Ai-Weiwei-switches-media-to-make-12285299.php

124. Morgan, David. "Review: Ai Weiwei's 'Human Flow,' on the plight of refugees." *CBS*, October 14, 2017. https://www.cbsnews.com/news/review-ai-weiwei-documentary-human-flow-on-the-plight-of-refugees/

125. Blancaflor, Saleah. "To Learn More About the Refugee Crisis, Ai Weiwei Turned to a New Medium: Film." *NBC*, October 12, 2017. https://www.nbcnews.com/news/asian-america/learn-more-about-refugee-crisis-ai-weiwei-turned-new-medium-n809926

126. Merten, Luiz Carlos. "Weiwei e a arte de focar no humano." *Última Hora News*, October 20, 2017. http://www.ultimahoranews.com.br/em-foco/2017/10/9578/weiwei-e-a-arte-de-focar-no-humano.html

127. Wilner, Norman. "Ai Weiwei follows the flow of the refugee crisis." *Now Toronto*, October 19, 2017. https://nowtoronto.com/movies/features /ai-weiwei-human-follows-flow-refugee-crisis/

128. Lawless, Jill (AP). "Ai Weiwei puts human face on migrant crisis in 'Human Flow.'" *Chicago Tribune*, September 2, 2017. http://www.chicagotribune.com /entertainment/sns-bc-eu--venice-film-festival-ai -weiwei-20170901-story.html

129. Köckritz, Angela, and Miao Zhang. "There's no point crying." *Zeit Online*, August 13, 2015. http:// www.zeit.de/politik/ausland/2015-08/ai-weiwei -artist-china-germany

130. Johnson, Brian D. "Ai Weiwei, an artist in exile, turns to the refugee crisis." *Maclean's*, September 29, 2017. http://www.macleans.ca/culture/movies /ai-weiwei-an-artist-in-exile-turns-to-the-refugee-crisis/

131. Venafro, Cinzia. "Ich weiss, dass meine Auftritte lächerlich wirken." *Blick*, November 11, 2017. https://www.blick.ch/news/politik/kuenstler-ai-weiwei -zeigt-der-welt-das-fluechtlingselend-ich-weiss -dass-meine-auftritte-laecherlich-wirken-id7583759.html

132. "We could all be potential refugees." *Toronto International Film Festival*, October 20, 2017. http://www.tiff.net/the-review/we-could-all-be-potential-refugees/

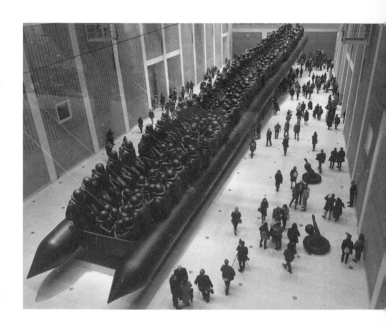

CHRONOLOGY

1910

Ai Qing, Ai Weiwei's father, is born in Zhejiang Province on March 27.

1911–1949

The Xinhai Revolution overthrows the Qing dynasty in 1911, ending two millennia of imperial rule. The Republic of China is founded; Sun Yat-sen (1866– 1925) is elected its first provisional president on December 29, 1911. A period of instability follows, including an attempt to revive the monarchy, the Warlord Era, the Second Sino-Japanese War, and the Chinese Civil War between the Nationalists and the Chinese Communist Party.

1929–1932

Ai Qing studies painting in Paris and discovers a love for poetry.

1932–1935

Ai Qing returns to China and joins the League of
Left-Wing Writers in Shanghai. Imprisoned for three
years by the Nationalists, he nonetheless writes
and publishes poetry.

1941–1943

Ai Qing meets Mao Zedong (1893–1976). Mao
organizes the Yan'an Forum on Art and Literature
and delivers a seminal speech on the relationship
between art and politics. Ai Qing joins the Chinese
Communist Party in 1943.

1949

The Chinese Communist Party, led by Mao, takes control
of mainland China and establishes the People's
Republic of China on October 1.

1956–1957

The Chinese Communist Party encourages citizens to express opinions and openly criticize national policies, a period of liberalization subsequently known as the Hundred Flowers Campaign.

1957

Ai Weiwei is born in Beijing on May 18, to Ai Qing and his wife, Gao Ying (1934–).

1957–1959

The Anti-Rightist Movement (1957–1959) immediately follows the Hundred Flowers Campaign. Hundreds of thousands of intellectuals are persecuted on allegations of "rightism" and face punishments ranging from public criticism to exile.

Ai Qing is denounced as a rightist and exiled to Beidahuang, Heilongjiang Province, in northeast China together with his family. They are transferred to Shihezi, Xinjiang Province, in northwest China in 1959.

1966–1976

Mao initiates the Great Proletarian Cultural Revolution
in May 1966, aiming to enforce Communism by
removing capitalist, traditional, and cultural elements
from Chinese society. Millions are accused of partici-
pating in "bourgeois" activities, suffering public
humiliation, imprisonment, torture, seizure of prop-
erty, and various forms of harassment. Numerous
historic sites and cultural artifacts are destroyed.

Ai Qing is sent away to a rural region of Xinjiang Prov-
ince to undergo further thought-reform through
hard labor. He and his family return to Beijing in
1975.

1976

Mao passes away at the age of eighty-two on September
9. Thereafter, the political faction known as the Gang
of Four is arrested, marking the end of the Cultural
Revolution.

1978

Reinstated as leader of the Chinese Communist Party, Deng Xiaoping (1904–1997) promotes economic reform and "opening up" to the outside world, driving China toward a market-oriented economy. Although China reopens its doors to the world, the political regime remains a dictatorship, maintaining strict social and media control.

Ai Weiwei enrolls at the Beijing Film Academy and studies animation as part of the first class of students admitted after the Cultural Revolution.

1979

Rehabilitated, Ai Qing becomes a vice-chairman of the China Writer's Association.

Ai Weiwei is a founding member of the Stars, the first movement to break away from the official aesthetic policies of the Chinese Communist Party. The first Stars exhibition takes place outside the National Art Museum.

1981–1982

Ai Weiwei studies English in the United States, in
Philadelphia, Pennsylvania, and then in Berkeley,
California.

1983–1993

Ai Weiwei relocates to New York in 1983, studying
briefly at the Parsons School of Design and the Art
Students League. Ai makes a living from odd jobs,
such as carpentry, babysitting, freelance photog-
raphy, and street portraiture. He frequently visits
museums and galleries and becomes influenced by
Marcel Duchamp (1887–1968) and Andy Warhol
(1928–1987).

1988

Ai Weiwei holds his first solo exhibition at Ethan Cohen/
Art Waves in New York.

1989

On April 15, the death of Hu Yaobang (1915–1989), the
purged Chinese Communist Party general secretary,

sparks public mourning that turns into a nationwide protest demanding freedom and democracy. Government troops with tanks enter Beijing and crush the demonstrations at Tiananmen Square on June 4. Many civilians are killed, the exact number unknown owing to the government's refusal to release an official death toll.

1993–1996

Ai Weiwei returns to Beijing for the first time in twelve years to care for his ailing father. Ai begins collecting antique furniture and pottery, and edits and publishes underground publications promoting the Chinese avant-garde. Ai Qing passes away on May 5, 1996.

1997

Ai Weiwei, with Hans van Dijk (1946–2002) and Frank Uytterhaegen (1954–2011), establishes the China Art Archives and Warehouse in Beijing, the first independent contemporary art space in China.

1999

Ai Weiwei designs and builds his studio house in Caochangdi, a village on the outskirts of northeast Beijing.

Ai Weiwei participates in the 48th Venice Biennale, curated by Harald Szeemann (1933–2005).

2001

Ai Weiwei establishes Beijing Fake Cultural Development Ltd., his design and architectural practice.

2002–2008

Ai Weiwei collaborates with the Swiss architects Herzog & de Meuron on the design of Beijing's National Stadium for the 2008 Summer Olympic Games. The team's submission wins the bid in April 2003; construction of the stadium is completed in June 2008.

2003

The Golden Shield Project, the "Great Firewall of China," begins operations in China. This censorship and

surveillance project blocks all websites and online information considered "sensitive." Websites affected include Google, Twitter, YouTube, and Facebook.

2005

Ai Weiwei begins an online blog at the invitation of Chinese web portal SINA. Ai's wide-ranging writings include social commentary, political criticism, and his thoughts on art and architecture.

2007

Ai Weiwei presents *Fairytale* at documenta 12, bringing 1,001 Chinese citizens to Kassel, Germany.

2007–2008

Ai Weiwei criticizes the Beijing Olympic Games and refuses to participate in the government's propaganda campaign. Despite his role in designing the Beijing National Stadium, he does not attend the Olympics' opening ceremony.

2008–2010

The Jiading district local government in Shanghai invites
Ai Weiwei to design and build a studio in Malu
township.

An 8.0-magnitude earthquake strikes Sichuan Province
on May 12, 2008, killing over eighty thousand peo-
ple. Thousands of the victims are students, trapped
in collapsing school buildings. The disaster leads
many to question quality and safety standards.

In response to the Chinese government's lack of trans-
parency, Ai Weiwei recruits volunteers through his
blog and launches a Citizens' Investigation to com-
pile a list of student victims. Through the Citizens'
Investigation, the first large-scale, social-media-
enabled civil rights action in China, 5,196 student
names and birthdates are confirmed.

2009

As Ai Weiwei continues to blog about the earthquake
and release data from the Citizens' Investigation—
penning over twenty-seven hundred posts and
attracting more than twelve million visitors—his

blog is shut down permanently. He begins using
Twitter and tweets at @aiww.

Ai Weiwei travels to Chengdu on August 12 to testify
on behalf of Tan Zuoren (1954–), a writer-activist
investigating the shoddy construction of collapsed
schools accused of "inciting subversion of state
power." During the night before the trial, the police
raid Ai's hotel room and detain him to prevent his
testifying. An officer beats him on the head during
the altercation.

In September, as Ai prepares his *So Sorry* exhibition at the
Haus der Kunst in Munich, he is found to be
suffering from a brain hemorrhage caused by the
beating in Sichuan, and undergoes emergency
surgery.

2010

The public art sculpture *Circle of Animals / Zodiac Heads*
debuts at the São Paulo Biennial in September.

Ai Weiwei also presents *Sunflower Seeds*, a large-scale
installation in the Tate Modern's Turbine Hall in
London, on October 12. The work comprises over

one hundred million hand-sculpted and painted porcelain sunflower seeds, crafted by sixteen hundred artisans from Jingdezhen, a city known for porcelain production since the Ming dynasty (1368–1644).

2010–2011

The Shanghai government informs Ai Weiwei on November 3, 2010, that his newly built studio is an illegal construction and must be demolished. In response, Ai organizes a river crab feast at the site, inviting his supporters. The police place Ai Weiwei under house arrest to prevent his attendance. The feast takes place without him on November 7, 2010. On January 11, 2011, Ai Weiwei's Shanghai studio is demolished with less than twenty-four hours' notice.

2011

As the Jasmine Revolution sweeps across North Africa and the Middle East, the Chinese Communist Party launches a major crackdown on dissidents in China. By some estimates, over two hundred dissidents,

lawyers, activists, and writers in China are arrested or forced to disappear.

Chinese secret police arrest Ai Weiwei on April 3 at the Beijing Capital International Airport, and he is detained for eighty-one days. He is released "on bail, pending trial" without formal charges on June 22. His passport is confiscated. Tax authorities impose fines and back taxes totaling RMB 15 million on Fake Ltd. on November 1.

In May, *Circle of Animals / Zodiac Heads* goes on view in New York City at the Pulitzer Fountain near Central Park.

Supporters initiate a fund-raising campaign for Ai Weiwei's challenge of the tax case against Fake Ltd. Within ten days, from November 3 to 13, RMB 9 million are raised from over thirty thousand individuals.

2013

Ai Weiwei presents *S.A.C.R.E.D.* at a collateral event of the 55th Venice Biennale in the Church of Sant'Antonin in Castello, on May 29. Six large dioramas reproduce

scenes of his daily life during his 2011 detention. Ai
is unable to attend numerous exhibitions during the
five-year period of his travel ban.

On November 30, Ai Weiwei places a bouquet of fresh
flowers in the basket of the bicycle outside his studio
entrance, vowing to continue this practice until his
passport and travel rights are restored.

2014

On April 26, the 15 Years Chinese Contemporary Art Award
exhibition opens at the Shanghai Power Station of
Art. Before the exhibition opens to the public, Shang-
hai authorities remove all mentions of Ai's name and
his works from the venue, despite his having served
on the CCAA jury multiple times and having been the
recipient of its 2008 Lifetime Achievement Award.

On May 23, Ai Weiwei removes three of his works
from the Hans van Dijk: 5000 Names exhibition at the
Ullens Center for Contemporary Art in Beijing, pro-
testing the museum's omission of his name from the
press release and of all mention of his longtime col-
laboration with van Dijk.

@Large: Ai Weiwei on Alcatraz opens on Alcatraz Island in
San Francisco on September 27. A centerpiece is *Trace*,
consisting of 176 portraits of prisoners of conscience
rendered in LEGO bricks.

2015

Amnesty International awards Ai Weiwei the Ambassador
of Conscience Award for his work in defense of
human rights.

Ai Weiwei, Ai Weiwei's first solo exhibition in China,
opens in Beijing, jointly presented by Galleria
Continua and Tang Contemporary Art Centre.

On July 22, Ai Weiwei's passport is returned. Relocat-
ing to Berlin to live and work, Ai begins his Einstein
Visiting Professorship at the Berlin University of the
Arts.

In December, *Circle of Animals / Zodiac Heads* goes on view
at the National Gallery of Victoria in Melbourne, as
part of *Andy Warhol / Ai Weiwei*. Breaking attendance
records, the exhibition draws nearly four
hundred thousand visitors.

2015–2016

Ai Weiwei visits the Greek isle of Lesbos, witnessing firsthand the incoming boats and meeting the arriving refugees.

Ai Weiwei decides to produce a feature-length documentary on the global refugee condition. Filmed over the course of one year, *Human Flow* is a visual expression of the greatest human displacement since World War II. Ai and the film team visit over forty refugee camps across twenty-three countries and conduct over six hundred interviews.

2016–2017

Ai Weiwei creates several large-scale installations in reaction to the global refugee condition, including *Safe Passage*, *Laundromat*, and *Law of the Journey*.

2017

On August 30, *Human Flow* makes its worldwide premiere
at the 74th Venice Film Festival in competition, and
its American premiere at the 44th Telluride Film Fes-
tival on September 3.

ACKNOWLEDGMENTS

The words and ideas expressed on these pages belong to Ai Weiwei, yet this book came about thanks to many individuals and their dedication to Ai Weiwei's vision.

We are first and foremost grateful to Ai Weiwei and his entire studio for their assistance with this publication and other projects. Special thanks to Jennifer Ng and Darryl Leung. Thanks as well to Max Logsdail, Chin-Chin Yap, and Nadine Stenke.

Our sincerest appreciation to everyone at Princeton University Press, including Michelle Komie, Terri O'Prey, Pamela Weidman, Lauren Lepow, Erin Suydam, Julia Haav, Kimberley Williams, and the entire PUP staff for their outstanding professionalism, support, and enthusiasm.

Special thanks to Fiona Graham for her excellent research that constitutes the foundation of this publication. Thanks to Taliesin Thomas for her coordination and management, and Zara Hoffman and Steven Rodríguez for their diligent assistance. Our special thanks as well to J. Richard Allen and to Andrew Cohen.

As always, I thank my wife, Abbey, and my children, Justin, Ethan, Ellie, and Jonah, for their openness and support of this serious and difficult subject. To my parents, my deepest gratitude and respect for leaving their home in search of freedom and a life beyond oppression.

Finally, I am immensely grateful to Ai Weiwei for so many things. As a longtime friend and collaborator, he continues to teach me so much about art and life. It is an honor to work so closely with such an extraordinary artist and humanist. His steadfast commitment to the worldwide refugee crisis, freedom of expression, human rights, and basic dignity for all people is unparalleled among his peers. While all our work together has been very meaningful, this project is particularly close to home, and I am most thankful for the opportunity to bring these words to the public.

<div align="right">

LARRY WARSH
NEW YORK CITY
JANUARY 18, 2018

</div>

Ai Weiwei is renowned for making strong aesthetic statements that resonate with timely phenomena across today's geopolitical world. From architecture to installations, social media to documentaries, Ai uses a wide range of mediums as expressions of new ways for his audiences to examine society and its values. Recent exhibitions include *Good Fences Make Good Neighbors* with the Public Art Fund in New York City; *Ai Weiwei: Trace at Hirshhorn* at the Hirshhorn Museum and Sculpture Garden in Washington, DC; *Maybe, Maybe Not* at the Israel Museum in Jerusalem; *Law of the Journey* at the National Gallery in Prague; *Ai Weiwei. Libero* at Palazzo Strozzi in Florence; *translocation — transformation* at 21er Haus in Vienna; *Circle of Animals / Zodiac Heads* at the Carnegie Museum of Art in Pittsburgh; and *Ai Weiwei* at the Royal Academy of Arts in London.

Born in Beijing in 1957, Ai currently resides and works in Berlin. Ai is the Einstein Visiting Professor at the Berlin University of the Arts (UdK); he is the recipient of the 2015 Ambassador of Conscience Award from Amnesty International and the 2012 Václav Havel Prize for Creative Dissent from the Human Rights Foundation. Ai's first feature-length documentary *Human Flow* premiered at the 74th Venice Film Festival in competition.

LARRY WARSH has been active in the art world for more than thirty years. He is an early collector of Ai Weiwei and has collaborated with the artist on several significant projects, including the public art installation *Circle of Animals / Zodiac Heads* (2010), which has been presented at more than forty venues internationally and seen by millions worldwide.

Warsh has been involved in numerous publishing projects over the last three decades, including original monographs on the art of Jean-Michel Basquiat, Keith Haring, and Ai Weiwei. He was also the catalyst and executive producer of the award-winning documentary *Ai Weiwei: Never Sorry* (2012).

Warsh is a former member of the Contemporary Arts Council of the Asia Society and the Contemporary Arts Committee of the China Institute. He has served on the boards of the Alliance for the Arts and the Getty Museum Photographs Council. He was a founding member of the Basquiat Authentication Committee.

This broad subject of humanity and its progress has been a lifelong focus. In addition to his work with Ai Weiwei addressing the refugee crisis, Warsh is collaborating with artist Lawrence Weiner on *Out of Sight*, a project that aims to enrich the experiences of young people around the world, and to foster the ideals of humanity and compassion.

ILLUSTRATIONS